Claude Monet
クロード・モネ

TASCHEN
KÖLN LONDON LOS ANGELES MADRID PARIS TOKYO

CLAUDE MONET (1840–1926)

When the Impressionist painters first offered their pictures to the public eye in the 1870s, they were greeted with incomprehension and disapproval. Monet's painting *Impression, Sunrise* provided one critic with the key word for his pejorative article entitled "L'Exposition des Impressionnistes". Thus was born the name of an artistic movement, which by the turn of the century had established itself as pointing the way forward.

Claude Monet is regarded as the most important of the Impressionists. His landscapes are the embodiment of what is commonly thought of as Impressionist painting. Impressionist theory claims that we do not see an object as such, but rather the light in which it appears to us. Thus Monet, for instance, painted the portal of Rouen Cathedral at various times of day and under different weather conditions, showing us how the changing light affects its appearance. In his paintings of the sea and of his motifs from nature – landscapes, flowers and ultimately the water lilies in his greatest pictures from Giverny – Monet sought to capture the instant of a particular natural manifestation. In his opinion, it was the task of the artist "to represent what stands between the object and the artist, which is the beauty of the atmosphere, the impossible". Through his paintings, Monet was to come closer than almost any other artist to this – admittedly unattainable – aim.

Die impressionistischen Maler stießen zunächst auf Unverständnis und Ablehnung, als sie in den 70er Jahren des 19. Jahrhunderts mit ihren Bildern an die Öffentlichkeit traten. Mit seinem Bild *Impression, Sonnenaufgang* lieferte Monet einem Kritiker das Stichwort für den abwertenden Artikel „L'Exposition des Impressionnistes". Damit war der Name einer Kunstrichtung geboren, die sich um die Jahrhundertwende als richtungweisend etablieren sollte.

Claude Monet gilt als der bedeutendste Repräsentant der Bewegung. Seine Landschaftsbilder sind Inbegriff der gängigen Vorstellungen von impressionistischer Malerei. Die impressionistische Theorie besagt, daß wir nicht den Gegenstand als solchen sehen, sondern das Licht, in dem er uns erscheint. So malte Monet das Portal der Kathedrale von Rouen zu verschiedenen Tageszeiten und bei unterschiedlicher Witterung und zeigte so, wie sich dessen Erscheinung abhängig vom Licht ändert. Bei seinen Motiven – dem Meer, den Landschaften, Blumen und zuletzt den Seerosen in seinen besten Bildern in Giverny – ging es Monet darum, dem Augenblick einer Naturerscheinung im Bild Dauer zu verleihen. Die Aufgabe des Künstlers besteht für Monet darin, „darzustellen, was zwischen dem Objekt und dem Künstler steht, nämlich die Schönheit der Atmosphäre, das Unmögliche". Wie kaum ein anderer Maler hat sich Monet diesem – ungreifbaren – Ziel genähert.

Lorsque les peintres impressionnistes exposèrent pour la première fois leurs toiles vers 1870, ils se heurtèrent d'abord à l'incompréhension et au rejet. Avec son tableau *Impression, soleil levant,* Monet fournit à un critique le mot-clé pour son article défavorable intitulé « L'Exposition des impressionnistes ». Le nom d'une tendance artistique, qui fut déterminante vers le tournant du siècle, était né.

Claude Monet est considéré comme le plus illustre représentant de ce mouvement. Ses paysages sont l'incarnation même des idées fondamentales de la peinture impressionniste. La théorie de l'Impressionnisme énonce que l'objet n'est pas perçu en tant que tel, mais par la lumière dans laquelle il apparaît. Monet peignit par exemple le portail de la cathédrale de Rouen à divers moments de la journée et par tous les temps, montrant ainsi comment l'aspect de ce dernier se modifie selon l'éclairage. Dans ses marines et paysages, lorsqu'il peignait les fleurs et les nymphéas à Giverny, Monet cherchait à saisir un instant particulier du spectacle de la nature. Pour lui, la tâche du peintre consistait à « représenter ce qui se trouve entre l'objet et l'artiste, à savoir la beauté de l'atmosphère, l'impossible ». Avec ses toiles, Monet s'est approché de ce but – inaccessible – comme peu d'autres peintres, influençant de façon décisive la peinture moderne.

Cuando los pintores impresionistas presentaron sus cuadros en público por primera vez, en la década de 1870, chocaron al principio con la incomprensión y el rechazo. Monet, con su cuadro *Impresión, salida de sol,* proporcionó a un crítico el término clave para un artículo despectivo titulado «L'exposition des impressionnistes». Así nacía el nombre de una corriente artística que sería determinante hacia finales de siglo.

A Claude Monet se le considera el representante más destacado de los impresionistas. Sus paisajes constituyen los modelos por excelencia de la pintura impresionista. La teoría del impresionismo afirma que no vemos el objeto como tal, sino la luz que lo envuelve cuando lo miramos. Así, por ejemplo, Monet pintó la fachada de la catedral de Rouen a diferentes horas del día y en distintas condiciones climáticas, mostrando de ese modo que su aspecto varía según la iluminación. Ante el mar y sus otros motivos, los paisajes, las flores y, finalmente, los nenúfares de sus mejores cuadros de Giverny, Monet pretendía perpetuar en el cuadro el instante en el que se produce un determinado fenómeno natural. En su opinión, la tarea del artista consiste en «representar aquello que se encuentra entre el objeto y el artista, es decir, la belleza de la atmósfera, lo imposible». Monet es uno de los pintores que más se ha acercado con sus cuadros a esta meta inaccesible.

1870年代、印象派の画家たちが初めて作品を一般に公開した時、無理解と拒絶の嵐に迎えられた。ある批評家は、モネの《印象、日の出》の印象という言葉を取り上げ、「印象派展」と題した侮辱的な記事を書いた。新しい芸術運動はこのようにして名づけられ、20世紀を迎える頃には時代の先駆けとして確固たる地位を築くこととなる。

クロード・モネは印象派の中でも最大の功績を残した画家とされ、その風景画は、一般に印象派の絵画と考えられているものを体現している。印象主義では、事物そのものではなく、むしろ事物を映し出す光を見る。例えばモネは、一日の違う時刻や異なる天候の中でルーアン大聖堂の扉口を描き、光の変化によってどのように違って見えるかを示した。海景や自然のモティーフ——風景、花、そして一連の傑作となったジヴェルニーの睡蓮——を描いた作品の中で、モネは自然のある一瞬の表情を捉えようとした。「事物と画家との間にある情調や捉えがたいものの美を表現すること」が画家の使命だとモネは語っている。作品を通して、モネは他の画家たちの誰よりも、この到達し得ない目標に近づいたのだった。

© 2002 TASCHEN GmbH
Hohenzollernring 53, D–50672 Köln
www.taschen.com

Original edition: © 2001 TASCHEN GmbH
© All images provided by te Neues Verlag, Kempen
Cover: Water-Lilies, 1916–1919
Printed in Hong Kong
ISBN 3-8228-1413-X

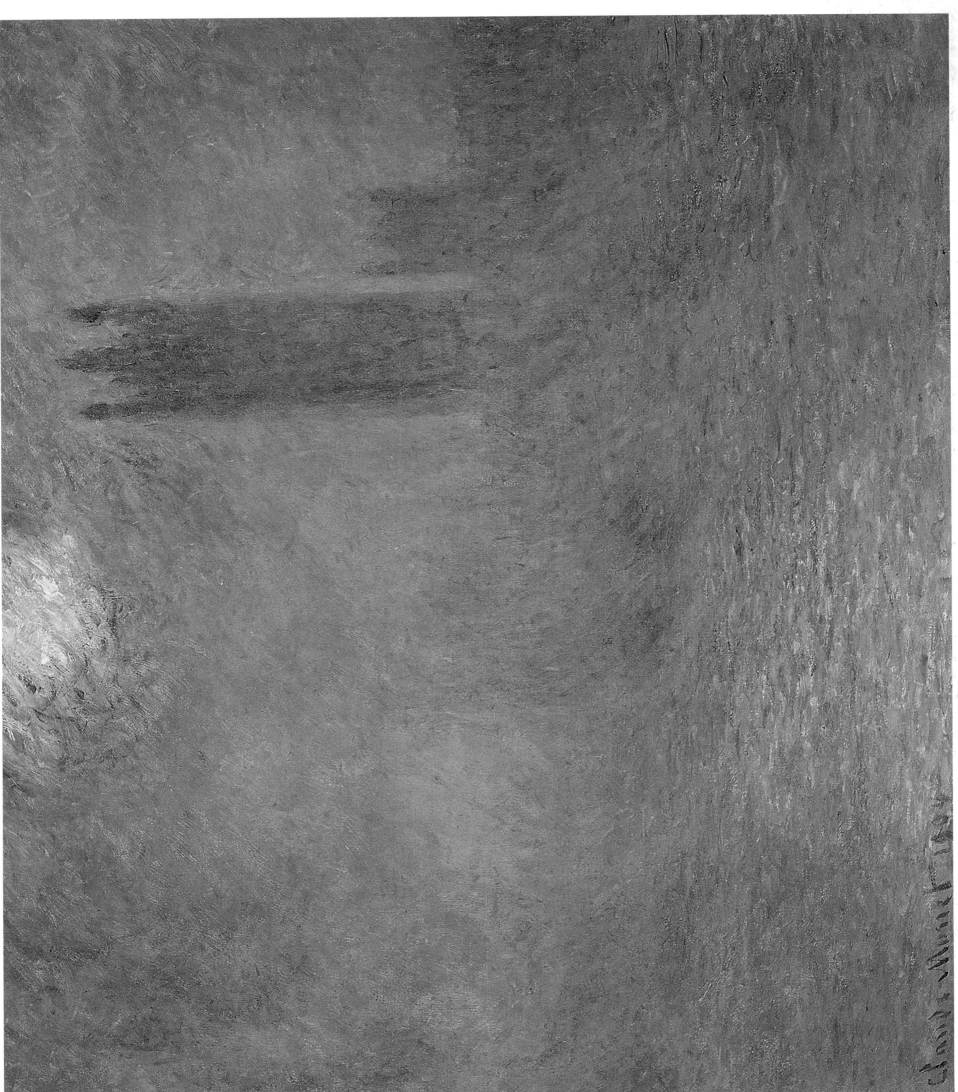

Claude Monet · Houses of Parliament, Effect of Sunlight in the Fog

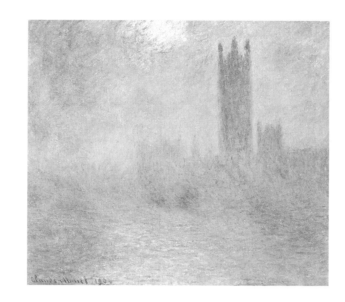

Claude Monet
Houses of Parliament, Effect of Sunlight in the Fog, 1904
Das Parlament, Sonnendurchbruch im Nebel
Le Parlement, trouée de soleil dans le brouillard
El Parlamento, traspasado de sol en la niebla
ロンドンの国会議事堂、霧を貫く陽光

Oil on canvas, 89 x 93 cm
Paris, Musée d'Orsay

For years, Monet continued to work on Thames scenes, with the Houses of Parliament or Waterloo Bridge, in his studio. The buildings rise enigmatically from their shrouds of shimmering fog, pierced by only a little sunlight.

Über Jahre hinweg arbeitet Monet in seinem Atelier immer wieder am Motiv der Themse mit dem Parlament oder der Waterloobrücke im Hintergrund. Chimärenhaft tauchen die Gebäude im dichten, nur von wenigen Sonnenstrahlen zu einem schillernden Gewebe belebten Nebel auf.

Des années durant, Monet travaille dans son atelier au motif de la Tamise avec le Parlement ou le Pont de Waterloo en second plan. Les édifices émergent comme un mirage de l'épais brouillard auquel quelques rayons de soleil donnent une scintillante texture.

Monet trabaja durante años en su estudio en el motivo del Támesis con el Parlamento o el puente de Waterloo al fondo. Los edificios surgen entre la espesa niebla –que unos pocos rayos de luz transforman en trémulo tejido– a modo de quimeras.

モネは何年にもわたって、テムズ川の風景画を国会議事堂やウォータール―・ブリッジとともに

アトリエで描き続けた。一面に立ち込めるゆらめく霧にさし込む淡い陽光の中から、

建物が神秘的に浮かび上がっている。

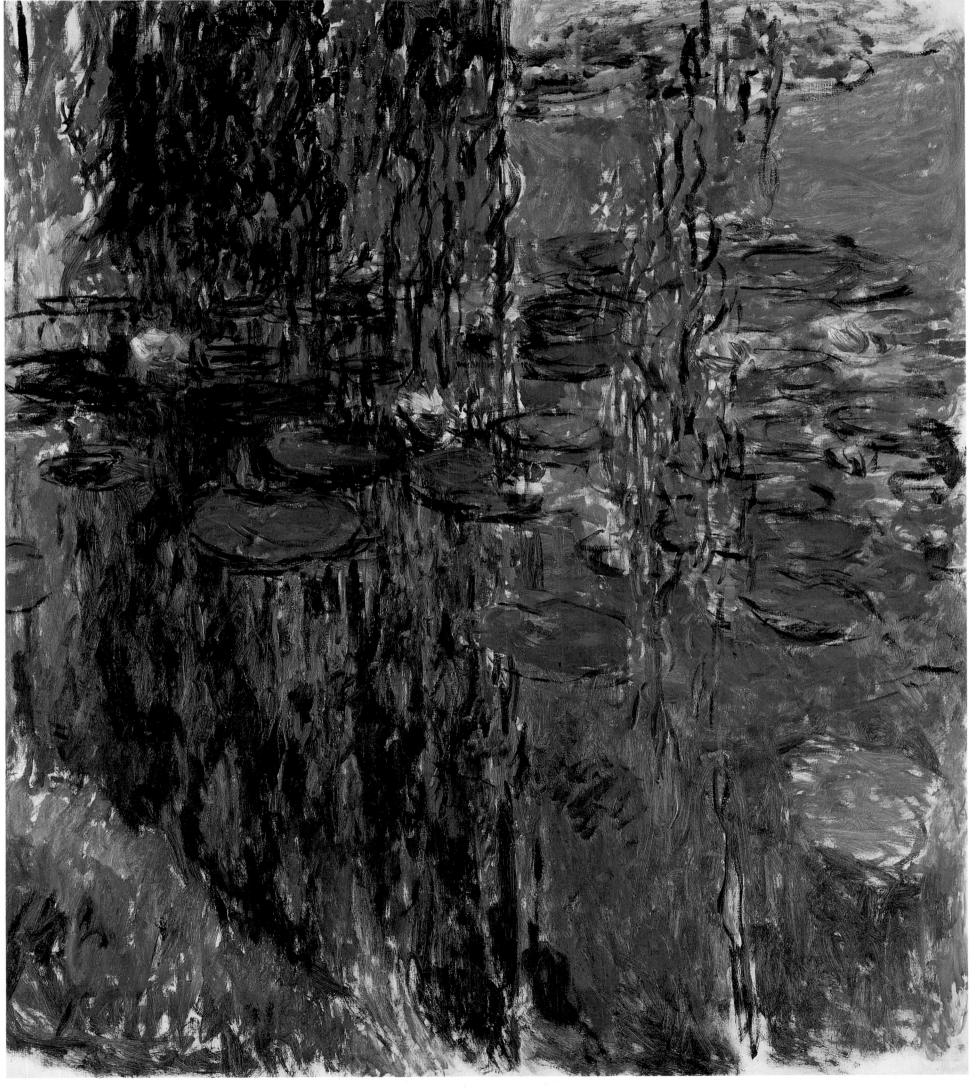

Claude Monet · Water-Lilies

Claude Monet
Water-Lilies, 1916–1919
Seerosen
Nymphéas
Nenúfares
睡蓮

Oil on canvas, 200 x 180 cm
Paris, Musée Marmottan

In his water-lily pool paintings, Monet went further than anywhere else in his art towards replacing representation with surface pattern or abstraction. With unparalleled skill and subtlety he catches a thousand vibrant nuances of colour, assembling them into a mosaic of light.

In den Bildern des Seerosenteichs findet sich die Auflösung des dargestellten Gegenstandes in die Fläche am weitesten vorangetrieben. In einem nie zuvor erreichten Maße ist die Farbe hier als in tausend Nuancen zerlegte, vibrierende Fläche, als Schleier, Licht und Mosaik aufgelegt.

C'est dans les toiles des nymphéas que la désintégration de la forme va le plus loin. Elle est plus que jamais présente, en vibrants aplats morcelés aux mille nuances, en voile, en lumière, en mosaïque.

En los cuadros de ninfeas se produce, con más intensidad que nunca, una disolución del objeto representado en la superficie. En una medida no alcanzada hasta entonces, el color se halla descompuesto en miles de matices, de superficies vibrantes; ha sido aplicado como velo, como luz, como mosaico.

睡蓮の池を描いた作品の中で、モネはそれまで以上に具象画から皮相的な模様や

抽象画へと移っていった。比類なき技量と精妙さでもって、モネは無数の微妙な色合いを捉え、

それを光のモザイクの中に結集させた。

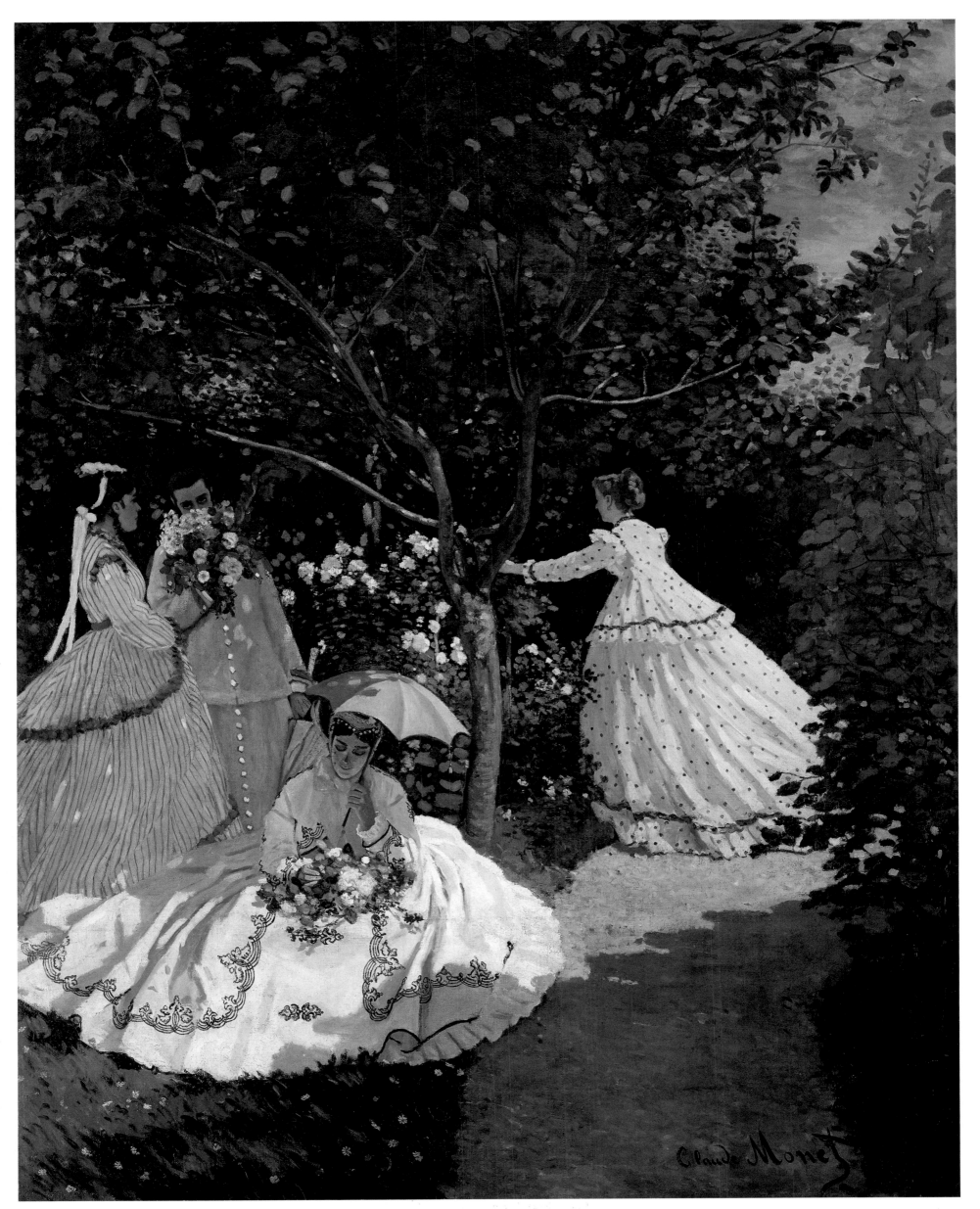

Claude Monet · Women in the Garden

Claude Monet
Women in the Garden, 1867
Frauen im Garten
Femmes au jardin
Mujeres en el jardín
庭の女たち

Oil on canvas, 255 x 205 cm
Paris, Musée d'Orsay

The freshness of his treatment was new, and the contrastive force with which he represented his figures in the open air possessed an unconstrained power. It may be that *Women in the Garden* revealed Monet's subject to him for the first time: light.

Mit einer nie zuvor dagewesenen Frische und in unverfroren starken Kontrasten werden die Figuren in Licht und Schatten der freien Natur gestellt. Vielleicht ist es ihm selber erst bei diesem Bild in aller Konsequenz klargeworden – Monet hat sein Thema gefunden: das Licht.

Avec une fraîcheur absolument nouvelle et des contrastes d'une grande vigueur les personnages sont placés au cœur de la lumière et des ombres. En tout cas, une chose est sûre, il a trouvé son inspiration : la lumière.

Con una frescura hasta entonces nunca vista y en medio de fuertes contrastes, las figuras aparecen colocadas en la luz y la sombra de la naturaleza al aire libre. Tal vez en este cuadro Monet se haya dado cuenta, con todas sus consecuencias, de que ha encontrado su tema: la luz.

モネの捉え方は斬新で、屋外に人物を配した対照的な効果にはのびのびとした力強さがある。

この《庭の女たち》によって、モネは初めて自分のテーマ、すなわち光、を見出したようだ。

Claude Monet · Red Boats, Argenteuil

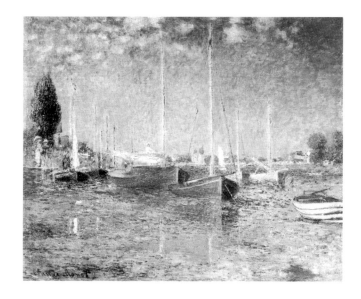

Claude Monet
Red Boats, Argenteuil, 1875
Rote Segelboote in Argenteuil
Les bateaux rouges, Argenteuil
Veleros rojos, Argenteuil
赤いボート、アルジャントゥイユ

Oil on canvas, 56 x 67 cm
Paris, Musée de l'Orangerie

From Eugène Boudin, who encouraged him to paint out of doors, Monet had learnt that whatever was painted on the spot, in the open, possessed an energy and vitality of brushwork that were unattainable in the studio.

Von Eugène Boudin, der ihn anregte im Freien zu malen, hat Monet gelernt, daß alles, was unmittelbar und an Ort und Stelle im Freien gemalt wird, eine Kraft und Lebendigkeit des Strichs hat, die im Atelier nicht erreicht werden kann.

Monet a appris d'Eugène Boudin que peindre sur le motif donne à la toile une force, une vitalité qu'il est impossible d'obtenir dans un atelier.

De Eugène Boudin, que le había animado a pintar al aire libre, Monet aprendió que todo cuanto se pinta directamente ante el motivo contiene una fuerza y viveza de pincelada inalcanzables en el estudio.

ウジェーヌ・ブーダンから、戸外で制作した絵にはアトリエでは得られない

エネルギッシュで生気溢れるタッチがあることを学ぶ。

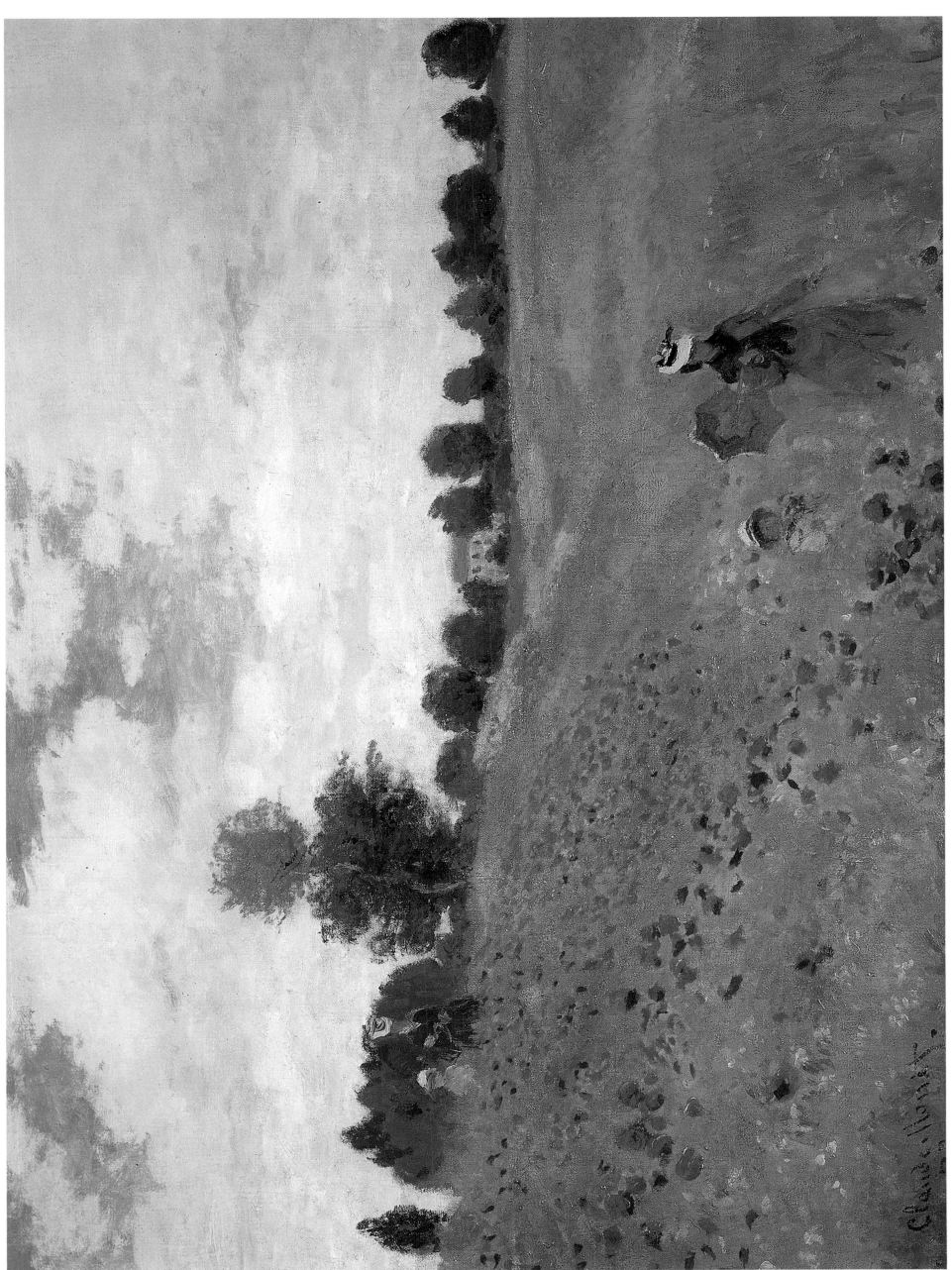

Claude Monet · Poppies at Argenteuil

Claude Monet
Poppies at Argenteuil, 1873
Mohnfeld bei Argenteuil
Les coquelicots à Argenteuil
Campo de amapolas en Argenteuil
アルジャントゥイユのヒナゲシ

Oil on canvas, 50 x 65 cm
Paris, Musée d'Orsay

"As a true Parisian, he takes Paris with him to the country," Emile Zola wrote of the early Monet. "He cannot paint a landscape without adding ladies and gentleman in their finery. Nature seems not to interest him if it does not bear the imprint of our way of life."

„Als ein wahrer Pariser, nimmt er Paris mit aufs Land", hatte Emile Zola über den frühen Monet geschrieben. „Er kann keine Landschaft malen ohne Damen und Herren in großer Garderobe hineinzusetzen. Die Natur scheint für ihn uninteressant zu werden, wenn sie nicht die Prägung unserer Lebensgewohnheiten trägt."

« En vrai Parisien, il emporte Paris à la campagne », disait Emile Zola du jeune Monet. « Il ne peut pas peindre un paysage sans y mettre des dames et des messieurs en grande toilette. On dirait que la nature ne l'intéresse que si elle porte la marque de nos mœurs. »

«Como un auténtico parisién, lleva París consigo al campo», había escrito Emile Zola sobre el temprano Monet. «No puede pintar un paisaje sin meter en ellos damas y caballeros lujosamente vestidos. La naturaleza parece perder interés para él si no lleva el sello de nuestras costumbres vitales».

「生粋のパリ人であるモネは、パリを郊外へ持ち出した。

モネは、着飾った男女なしでは風景を描くことができない。現代の生活を刻印することによって

自然に興味を示すようだ」と、エミール・ゾラは若きモネについて語った。

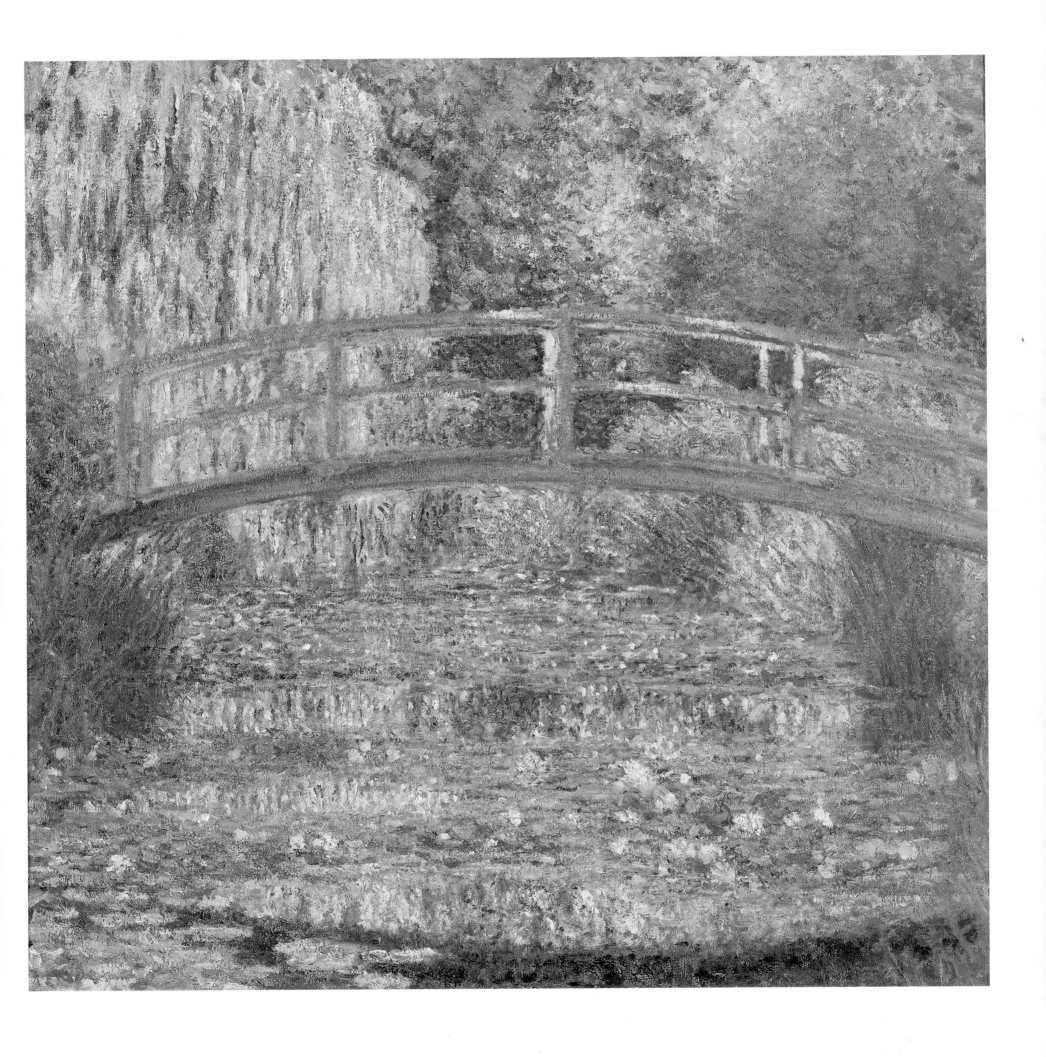

Claude Monet · Water-Lily Pond, Symphony in Green

Claude Monet
Water-Lily Pond, Symphony in Green, 1899
Der Seerosenteich, Harmonie in Grün
Le bassin aux nymphéas, harmonie verte
El estanque de las ninfeas, armonía verde
睡蓮の池、緑のシンフォニー

Oil on canvas, 89 x 93 cm
Paris, Musée d'Orsay

Inspired by Japanese woodcuts, Monet had a small Japanese-style wooden bridge built in 1895 in his garden. Overhung with wisteria, it became a subject in numerous later paintings.

In Anlehnung an japanische Holzschnitte baut Monet 1895 in seinem Garten die „passerelle japonaise", eine kleine Holzbrücke, die – mit einem dichten Glyzinienvorhang überwachsen – zum malerischen Motiv vieler seiner späten Bilder wird.

En 1895, Monet fait constuire dans son jardin la « passerelle japonaise », petit pont de bois qui, avec son rideau de glycine, sera le sujet de nombreuses toiles.

En 1895, Monet encarga construir, en su jardín, basándose en xilografías japoneses, la «passerelle japonaise», un pequeño puente de madera –cubierto por una espesa cortina de glicinas– que se convertirá en motivo de muchos de sus lienzos tardíos.

日本の木版画に霊感を得たモネは、1895年、自宅の庭に小さな木製の太鼓橋を作らせた。

フジの花が覆いかぶさるこの橋は、数多い後期作品の主題となった。

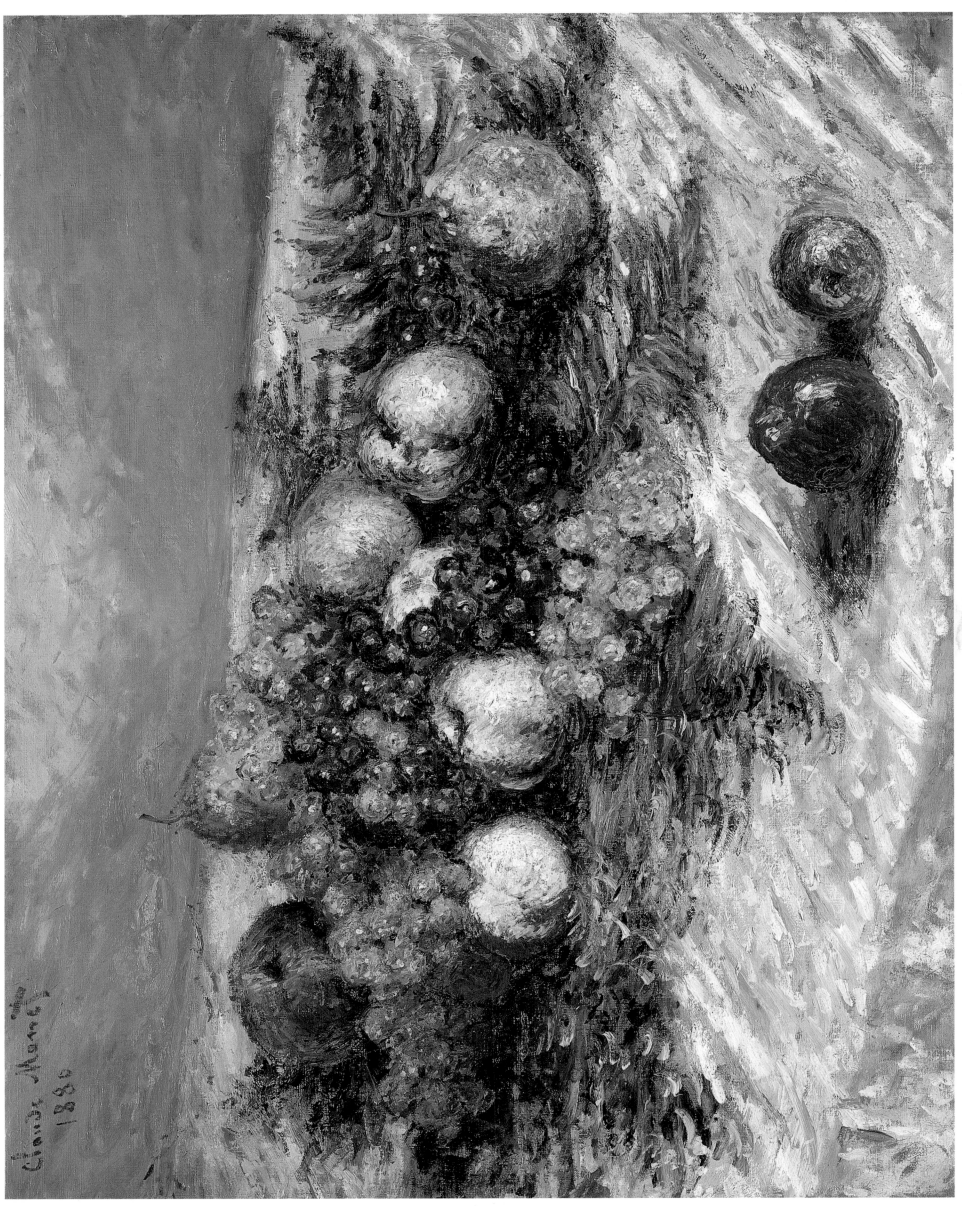

Claude Monet · *Pears and Grapes*

Claude Monet
Pears and Grapes, 1880
Birnen und Trauben
Poires et raisin
Peras y uvas
洋梨とブドウ

Oil on canvas, 65 x 81 cm
Hamburg, Hamburger Kunsthalle

Only at one period in his career, around 1880, did Monet give any significant
attention to still lifes. His fruit and flower pieces won wide admiration, although
he painted few of them.

Nur in den Jahren um 1880 spielten für Monet Stilleben eine größere Rolle.
Auch wenn seine Früchte- und Blumenstücke viele Bewunderer fanden,
so hat er nur wenige davon gemalt.

Les natures mortes n'eurent d'importance chez Monet qu'autour de 1880. Malgré
l'admiration qu'elles suscitaient, il n'en peignit que peu.

Las naturalezas muertas desempeñaron un importante papel en la carrera de Monet
únicamente hacia 1880. Aún cuando sus piezas de frutas y flores encontraron muchos
admiradores, Monet no pintó muchos de estos motivos.

1880年頃の一時期、モネは静物画に取り組んだことがあった。

モネの描いた果物や花々は広く賞賛されたが、これらの主題を描いた作品はごく僅かしかない。

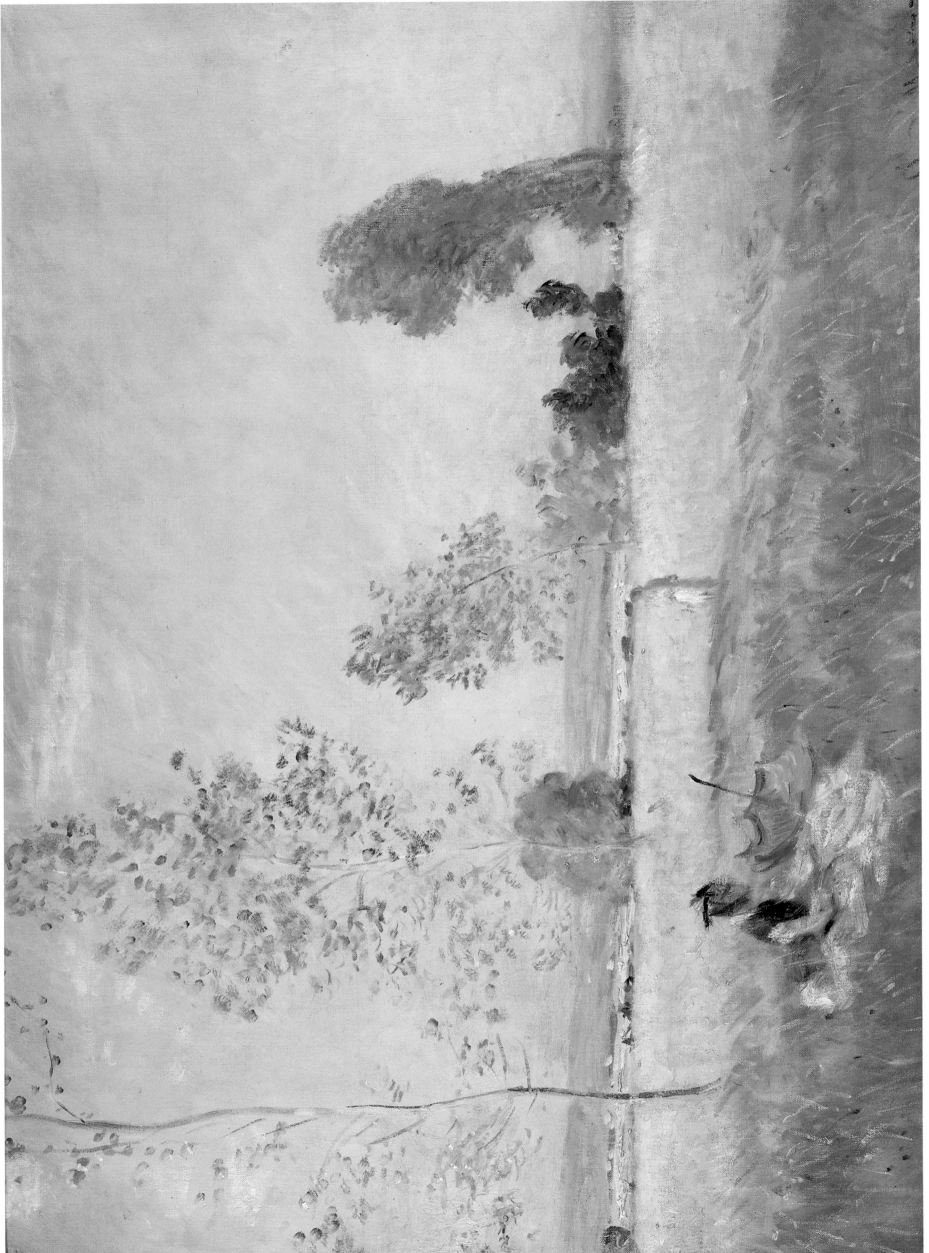

Claude Monet · Summer

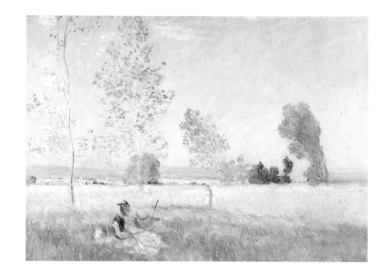

Claude Monet
Summer, 1874
Sommer
L'Eté
El Verano
夏

Oil on canvas, 57 x 80 cm
Berlin, Staatliche Museen zu Berlin – Preussischer Kulturbesitz

The wind and play of sunlight are evoked with an incredible freshness that is immediately evident. The landscape conveys a gay, light-hearted mood, reflecting the idylic phase of Monet's life during the years he spent in Argenteuil.

Der Wind und das Spiel des Sonnenlichts werden in unglaublicher Frische dargestellt. Die Landschaft vermittelt eine heitere und unbeschwerte Stimmung und spiegelt zugleich die glückliche Phase, die die Jahre in Argenteuil für Monet bedeuten.

On sent le vent et le jeu de la lumière solaire d'une manière extraordinairement fraîche et directe. Le paysage donne une atmosphère gaie et insouciante et reflète en même temps la phase des années d'Argenteuil.

Se percibe el viento y el juego de la luz del sol de un modo extraordinariamente fresco y directo. El paisaje transmite una impresión de alegría y despreocupación, y refleja la feliz etapa de los años de Argenteuil.

風と陽光のきらめきが、見るからに溢れんばかりの新鮮さで描かれている。

この風景画は、陽気で軽やかな雰囲気を伝え、モネがアルジャントゥイユで

過ごした年月の牧歌的な面を映し出している。

Claude Monet · Water-Lilies, Evening Effect

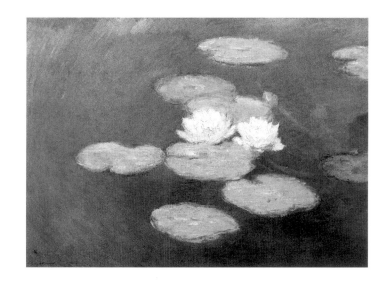

Claude Monet
Water-Lilies, Evening Effect, 1903
Seerosen am Abend
Nymphéas, effet du soir
Nenúfares, efectos del atardecer
睡蓮、夕暮れの印象

Oil on canvas, 73 x 100 cm
Paris, Musée Marmottan

During the last 30 years of his life, the water-lily garden and its surroundings became one of the central themes in Monet's paintings, forming a final epitome of his œuvre.

Der Seerosengarten und dessen Umgebung wurde in den letzten dreißig Jahren seines Lebens zu einem zentralen Thema von Monets Schaffen und zu einem letzten Höhepunkt seines Werks.

Le jardin aux nymphéas et ses environs devinrent pendant les trente dernières années de sa vie un thème central de sa peinture et un dernier point culminant de son œuvre.

El jardín con los nenúfares y sus alrededores se convirtieron en un tema central de su pintura durante los últimos treinta años de su vida y en el último punto culminante de su obra.

晩年の30年間、睡蓮の庭とその周辺はモネの作品の中心テーマとなり、

画家としての一生を締めくくるものとなった。

Claude Monet · The Reader

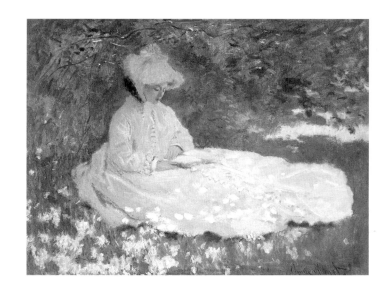

Claude Monet
The Reader, 1872
Die Lesende
La liseuse
La lectora
読書する女

Oil on canvas, 48,5 x 65,1 cm
Baltimore, Maryland, The Walters Art Gallery

The first few years at Argenteuil, during which he painted *The Reader* and other works, were a magical time for Monet. Financially secure for the time being, he settled into a relaxed life in a pleasant house and garden, painting some of his brightest pictures.

Eine goldene Zeit für Monet sind die ersten Jahre in Argenteuil, wo unter anderem das Bild *Die Lesende* entstand. Für eine Weile finanziell abgesichert, findet der Maler in einem hübschen Haus mit Garten Ruhe und Muße, um seine leuchtendsten Bilder zu malen.

Les premières années à Argenteuil, où il peint plusieurs tableaux dont *La liseuse*, sont une période bénie pour Monet. Débarrassé pour un temps des soucis financiers, le peintre trouve, dans un jolie maison avec jardin, le temps et la tranquilité nécessaire pour peindre ses toiles les plus lumineuses.

Los primeros años en Argenteuil, donde pintó –entre otros– el cuadro *La lectora*, constituyen una época dorada para Monet. Respaldado por una seguridad económica pasajera, el pintor encuentra en una bonita casa con jardín la paz y la inspiración para pintar sus cuadros más luminosos.

《読書する女》などの作品を制作したアルジャントゥイユでの最初の数年間は、

モネにとって魔法にかかったような時間だった。経済的にも安定していたこの一時期、

快適な家と庭でゆとりのある生活を送りながら、生涯でもっとも輝かしい絵の数々を描いた。

Claude Monet · The Luncheon

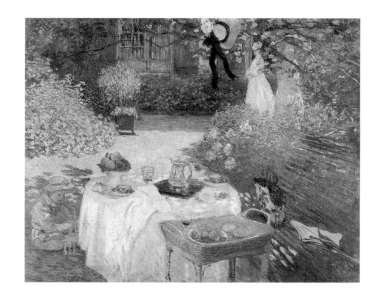

Claude Monet
The Luncheon, 1873
Das Mittagessen
Le déjeuner
El almuerzo
午餐

Oil on canvas, 160 x 201 cm
Paris, Musée d'Orsay

The background shows the garden front of the artist's first house in Argenteuil; the artist's son Jean is on the left.

Im Hintergrund sieht man die Gartenfassade des ersten Hauses, das der Künstler in Argenteuil bewohnte; links im Bild, Jean Monet, der Sohn des Künstlers.

On aperçoit au fond de ce tableau la façade sur jardin de la première maison habitée par l'artiste à Argenteuil ; à gauche, Jean Monet, le fils de l'artiste.

En el fondo del cuadro se aprecia la fachada que daba al jardín de la primera casa que el artista tuvo en Argenteuil; a la izquierda, Jean Monet, el hijo del artista.

アルジャントゥイユでモネが最初に住んだ家の庭の正面が背景となっており、

左のほうには息子のジャンが見える。

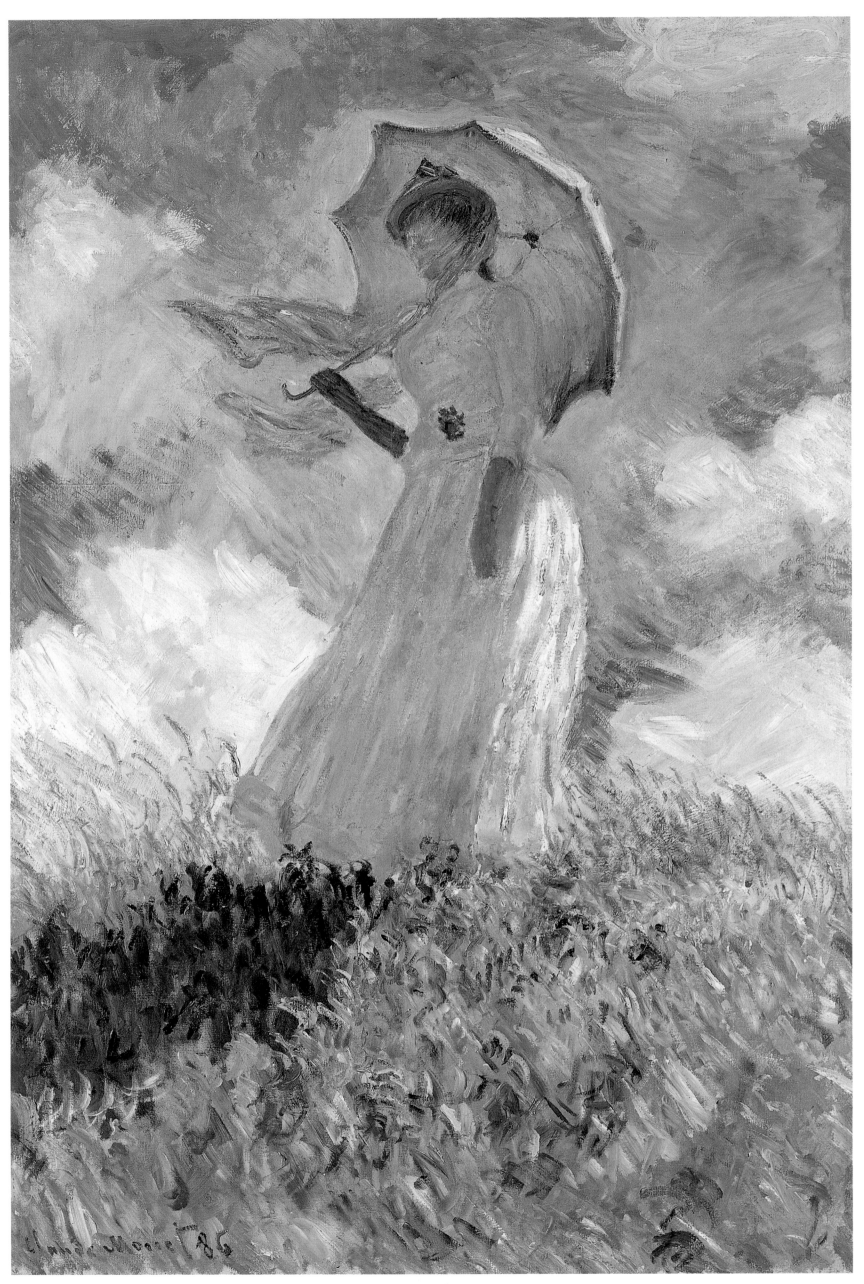

Claude Monet · Woman with a Parasol (Facing left)

Claude Monet
Woman with a Parasol (Facing left), 1886
Frau mit Sonnenschirm (nach links gewandt)
La femme à l'ombrelle (vers la gauche)
Mujer con sombrilla (vuelta a la izquierda)
パラソルをさす女 (左向き)

Oil on canvas, 131 x 88 cm
Paris, Musée d'Orsay

Here the artist depicts Suzanne Hoschedé (1868–1899) standing on the embankment of the Ile aux Orties, and posing in the style of "woman with a parasol".

Der Künstler zeigt hier Suzanne Hoschedé (1868–1899) auf der Böschung der Ile aux Orties als „junge Frau mit Sonnenschirm".

L'artiste représente ici, debout sur le talus de l'île aux Orties, Suzanne Hoschedé (1868–1899) en « jeune femme à l'ombrelle ».

Aquí, sobre el talud de la isla de Orties, el artista representa a Suzanne Hoschedé (1868–1899) en «Mujer con sombrilla».

この絵は、イル・オーゾルティーの丘に立ち、「パラソルをさす女」のポーズをした

シュザンヌ・オシュデ（1868-1899）を描いている。

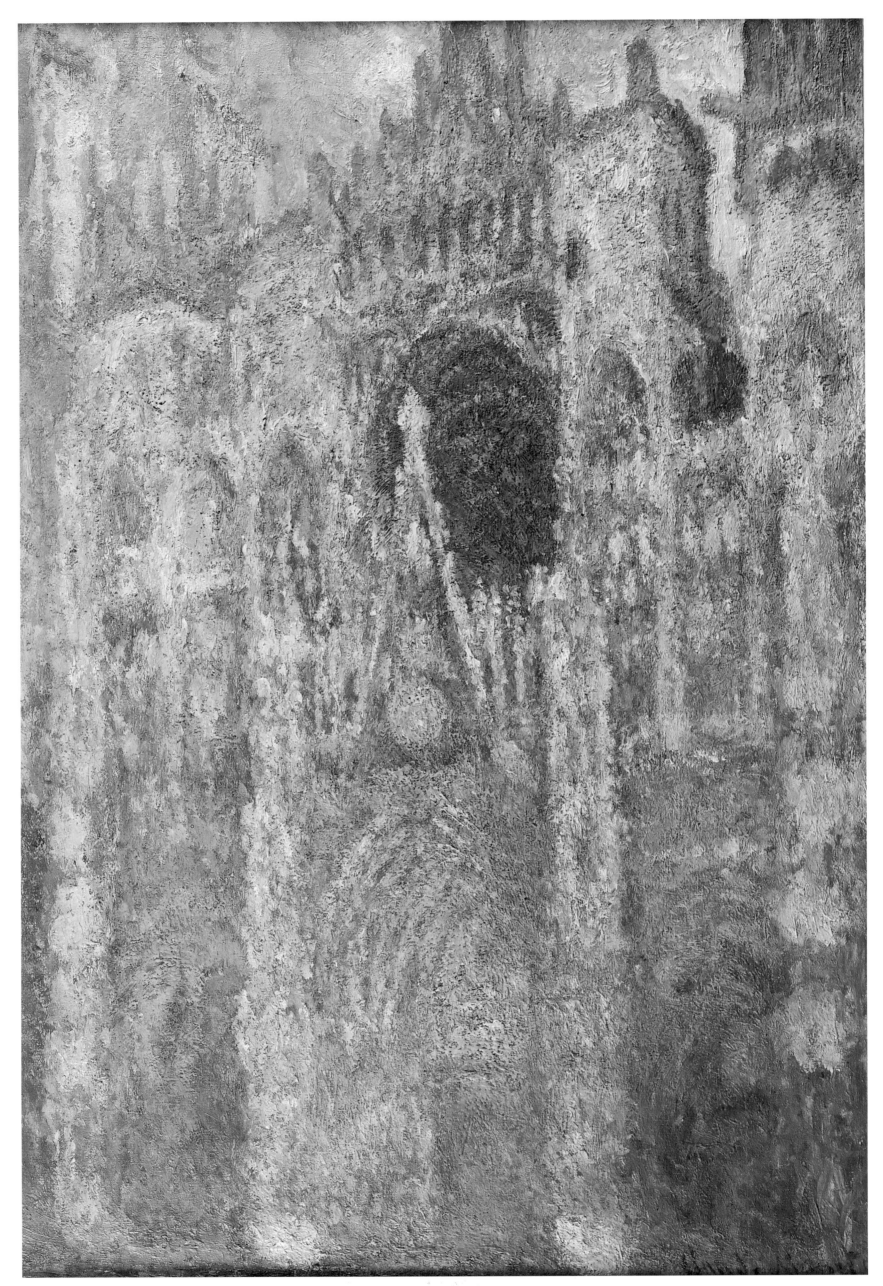

Claude Monet · The Cathedral in Rouen, The Portal, Harmony in Blue

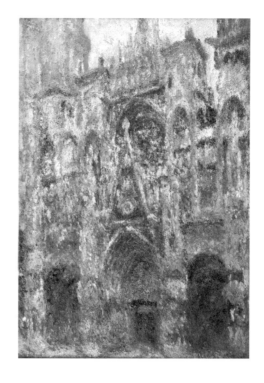

Claude Monet
The Cathedral in Rouen, The Portale, Harmony in Blue, 1893
Die Kathedrale von Rouen, das Portal, Harmonie in Blau
Cathédrale de Rouen, le portail, harmonie bleue
La catedral de Ruán, el Portal, armonía azul
ルーアン大聖堂、扉口、青のハーモニー

Oil on canvas, 91 x 63 cm
Paris, Musée d'Orsay

The direction in which Rouen cathedral faces is such that the sun begins to illuminate the facade, from right to left, after 12 o'clock. Monet therefore insisted on being "at work from midday to two o'clock" in order to capture this effect.

Die Kathedrale von Rouen ist so gebaut, daß die ersten Sonnenstrahlen die Fassade nach 12 Uhr von rechts nach links streifen. Monet legt großen Wert darauf, „von Mittag bis zwei Uhr bei der Arbeit zu sein", um diese Stimmung festzuhalten.

L'orientation de la cathédrale de Rouen est telle que le soleil commence à effleurer la façade, de droite à gauche, après 12 heures. Aussi Monet a-t-il tenu à « être au travail à midi jusqu'à deux heures » pour noter cet effet.

La orientación de la catedral de Rouen es tal que el sol comienza a rozar la fachada, de derecha a izquierda, después de las doce. Monet concedió mucha importancia a «estar en el trabajo de mediodía a las dos de la tarde» para plasmar este efecto.

ルーアン大聖堂は、太陽が正午過ぎに右から左へ正面を照らし始める方角を向いている。

モネはこの効果を捉えるために、どうしても「正午から午後2時にかけて制作する」と言い張った。

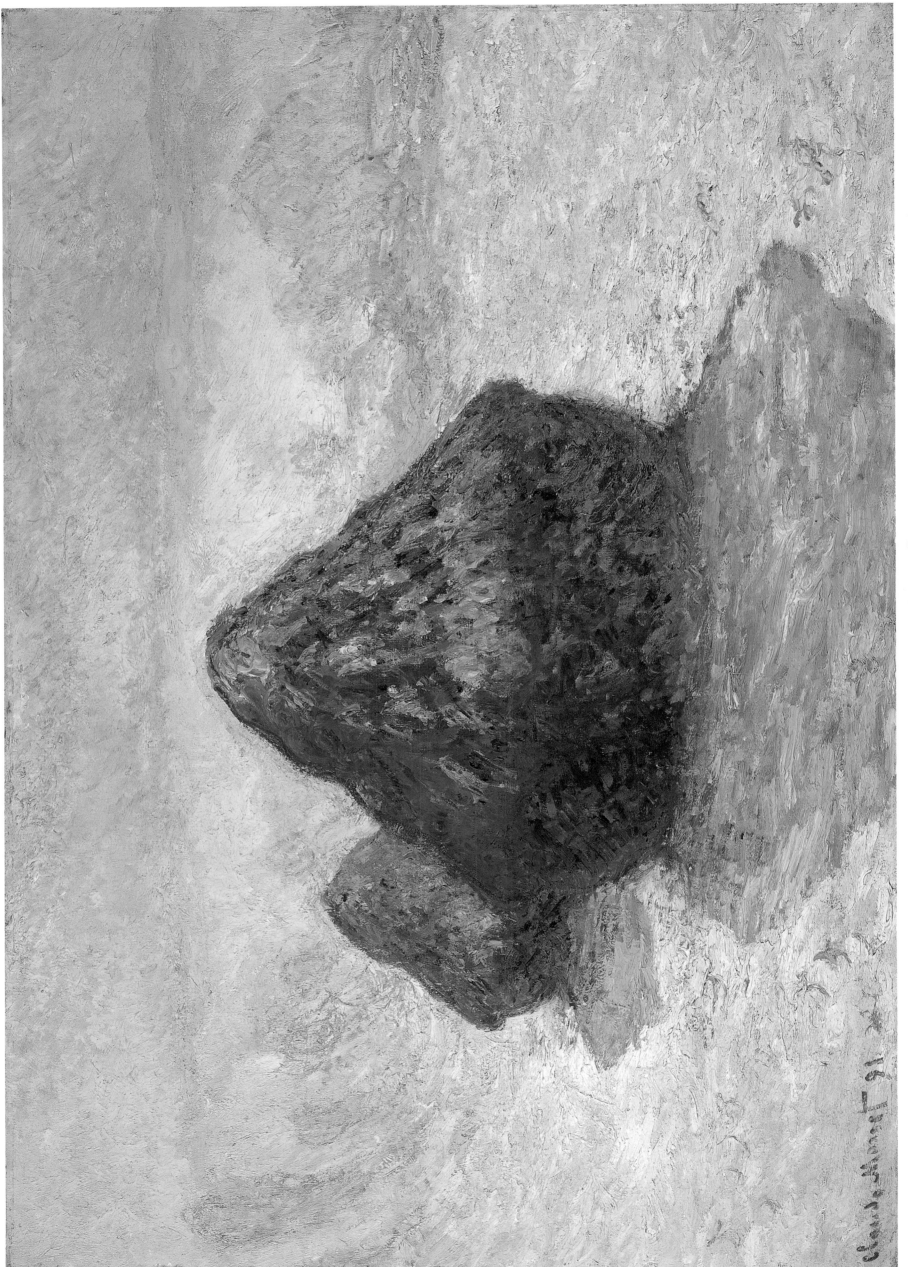

Claude Monet · Grainstacks, White Frost Effect

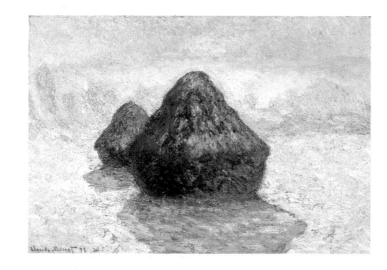

Claude Monet
Grainstacks, White Frost Effect, 1891
Getreideschober bei Rauhreif
Meules, effet gelée blanche
Almiares con escarcha
積みわら、白い霜の効果
·

Oil on canvas, 65 x 92 cm
Edinburgh, The National Gallery of Scotland

"For me, the subject is of secondary importance: I want to convey what is alive
between me and the subject."

„Das Sujet ist für mich von untergeordneter Bedeutung; ich will darstellen,
was zwischen dem Objekt und mir lebt."

« Le sujet a pour moi une importance secondaire ; je veux représenter ce qui
vit entre l'objet et moi. »

«El tema tiene para mí importancia secundaria; quiero representar lo que
vive entre el objeto y yo».

「私にとって、この主題は二次的なものにすぎない。

私は自分と主題の間に存在するものを伝えたいのだ」

CLAUDE MONET